FUROSHIKI

LAURENCE KING

First published in Great Britain in 2021
by Laurence King Publishing
an imprint of The Orion Publishing Group Ltd
Carmelite House, 50 Victoria Embankment
London EC4Y 0DZ

An Hachette UK Company

10 9 8 7 6 5 4 3 2 1

Design by Alexandre Coco
Edited by Chelsea Edwards
Furoshiki designed and produced by Tomoko Kakita
(maspacedesign.com)
Prop styling by Olivia Bennet

A CIP catalogue record for this book is
available from the British Library.

ISBN 978-191394-765-1
Printed in China by C&C Offset Printing Co. Ltd.

BOOK
CHAIN
PROJECT

www.laurenceking.com
www.orionbooks.co.uk

風呂敷

FUROSHIKI
AND THE
JAPANESE
ART OF GIFT
WRAPPING

TOMOKO KAKITA

PHOTOGRAPHY BY
STEPHANIE McLEOD

LAURENCE KING PUBLISHING

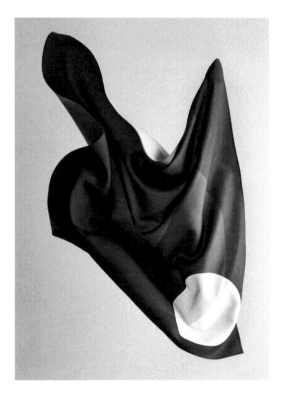

INTRODUCTION

In Japan, there exists the beautiful culture of wrapping treasured items, gifts and belongings in a piece of cloth called Furoshiki. The culture of wrapping items with a piece of cloth is common all over the world. However, Japanese Furoshiki culture is unique: it is not only a piece of art, there is a special courtesy about how and when to use it and there are various grades of Furoshiki size, material and colour.

The nature of Furoshiki is that you can use it again and again. Though the use of Furoshiki has faded since the 1970s because of the introduction of plastic bags, paper bags and wrapping paper, there is a gathering revival. What could be more eco-friendly and in line with the mantra of reduce, reuse and recycle than to use Furoshiki in your day-to-day life?

GIFT GIVING IN JAPAN

This is an important aspect of Japanese culture and people use it as a way of maintaining good relationships with those with whom they have connections and business. My memory about gift giving when I was in Japan was all about caring – caring about the receiver. There is a way of choosing gifts depending on the occasion, purpose and how much we know about the receiver. Gift giving is not only to hand a present to a person but also to consider how they feel, how they will carry the gift home and how they will use it. Importance is placed on the thoughtfulness of the act of gift giving and choice of the gift rather than its value.

There are gift-giving traditions and etiquette in Japan and there are textbooks about them, including how to wrap and unwrap a gift, when to give a gift and how to express thanks for a gift. Furoshiki protects your gift during transportation, but it would be considered rude not to take it away with you as you would be gifting any dust or dirt along with it. The Japanese believe that we keep and develop a good relationship with others by placing importance on the tradition and manner of exchanging gifts. We show our respect to others by following the etiquette of the custom.

ORIGINS OF FUROSHIKI

Furoshiki was originally known as 'Tsutsumi'. 'Tsutsumi' 包 in Japanese means 'wrap'.

The ancient letters that represented the word 'Tsutsumi' are shaped like a pregnant woman. The act of wrapping has become a metaphor for care and compassion.

Furoshiki is a piece of cloth that has various roles: to wrap, carry, protect and keep. The functionality is versatile according to the occasion for which it is used, as well as the shape and size of objects it covers. It reflects the Japanese sensibility, since ancient times, of accepting nature as it is.

HISTORY OF FUROSHIKI

710-94
NARA PERIOD
Precious linen cloth was used to wrap and protect treasures in temples. The cloth was called 'Tsutsumi' in this period. The oldest piece of wrapping cloth is held in the Shoso-In treasure house that belongs to Todai-Ji Temple, in Nara, from this period.

794-1185
HEIAN PERIOD
During this period the cloth was called 'Koromo Tsutsumi'. 'Koromo' in Japanese means 'clothes'. One of the old scrolls from this period show court ladies respectfully carrying noblemen's clothes wrapped in these cloths.

1185-1333
KAMAKURA PERIOD
At this time, the name changed to 'Hiratsutsumi'. The cloth was still used for wrapping the clothes of noble families and feudal lords. 'Origata' 折形 was born in this period and was established as an official courtesy for only high-ranking Samurai class families and recorded the methods in their secret books. Origata is a generic name for the formal way of wrapping gifts with decorative folded Japanese paper for ritual use.

1336-1573
MUROMACHI PERIOD
This period saw the first piece of cloth being used for Furoshiki. The story goes that Ashikaga Shogun Yoshimitsu invited lords to a steam bathhouse to entertain them. The guests changed while standing on Furoshiki. The bathers wrapped their clothes in a Furoshiki with their family crest marked on it to prevent their belongings from becoming confused. The noble families used a silk cloth for their rituals; in contrast, high-ranking Samurai used paper.

EDO PERIOD
(1603-1868)-1960S
As commercial trades started to flourish in Japan, traders wrapped their products for transportation. The travellers used Furoshiki for wrapping their belongings. Furoshiki became a necessity for people's everyday lives.

FUROSHIKI MATERIAL

Linen was the main material used for wrapping and protecting treasures at the beginning of Furoshiki history. At this time, the wrap was designed specifically with the contents in mind. The treasures were wrapped using the Flat Wrap method and tied using fabric string sewn to the wrap. Contents were listed on the wrap with ink.

Silk Furoshiki is considered an exclusive product and people use it for ceremonial and formal occasions. Specially crafted silk weaving and dyeing techniques were developed in the Kyoto region. Exclusive silk Furoshiki designs sometimes included embroidery and gold decorations.

Materials used for modern Furoshiki are silk, cotton, nylon, polyester, rayon and viscose. However, nylon, polyester, rayon and viscose are not the best options if you want to choose the most eco-friendly material. If we want to treat our planet with care and kindness, natural fibres such as cotton, silk, linen and hemp are the ethical choice of materials for Furoshiki.

SIGNIFICANCE OF COLOUR IN JAPAN

Many traditional colours of Japan have names that originate from plants and nature and there are subtle colour differences between them. Rules about colours have existed for as long as Furoshiki has. The meaning of colours, associated with the ranking system and occasions for use, was important for Japanese culture in the past. There were colours only the royal family and noble people could use. There are still two absolutely prohibited colours: 'Kourozen' 黄櫨染 is a red-yellow colour that represents the brilliance of the midsummer sun and 'Ouni' 黄丹 is a red-orange colour that represents the colour of the sunrise. Only the emperor is allowed to wear Kourozen and only the crown prince is allowed to wear Ouni - even in the present-day in Japan. Both colours are created with natural dyes.

When choosing the colours of your Furoshiki to wrap a gift, there are some meanings associated with different colours that are useful to know if you are in Japan.

- Purple 紫色: purple is traditionally considered a noble colour. It's a practical colour to have in your Furoshiki collection as you can use it regardless of whether it is a celebration or an occasion for condolence.

- Blue 青色: Japanese blue is called Ai 藍. It is a similar colour to indigo. The plant used for dyeing cloth was not only used for this purpose but was also applied to the skin, decocted and drunk, and eaten, and was an indispensable part of people's lives. A dark blue colour can be used for condolences. Brighter blue has a refreshing feeling and is popular in the summer season.

- Green 緑色: slightly muted and neutral green colours are suitable for condolences as well as celebration. Matcha green colour, known as 'Rikyu-iro' 利休色 is named after the famous tea master Sen no Rikyu 千利休 and was a popular colour during the Edo Period. Though it should be noted the colour is far duller than the bright green we associate with matcha tea today.

- Yellow 黄色: yellow is used for celebrations and is considered a prosperous colour. A golden-brown colour is achieved using a dye made from a grass plant; it has been a popular colour for a long time.

- Red 赤色: red is for celebrations to convey the feeling of joy. It is a popular colour to be used for celebrations such as engagements and weddings.

FUROSHIKI SIZES

It's important to note that Furoshiki is not square. Usually, it is slightly longer than it is wide. The reason for one side to be longer is to strengthen the fabric (all dimensions given in this book are shown as length x width).

There are about ten basic Furoshiki sizes. The measurements are still used amongst Furoshiki manufacturers. Below are some examples of different sizes and a guide to choosing the correct Furoshiki size for the intended contents. Sizes larger than Itsu-Haba are rarely seen these days as cardboard boxes and containers have replaced Furoshiki for bigger items.

- Chu-Haba 中巾 45 cm: envelope and small items.

- Shakumi-Haba 尺三巾 50 cm: lunch box and small items.

- Futa-Haba 二巾 68 cm: this is the most widely used size. Lunch box, sweets gift boxes and one wine bottle.

- Nishaku-Haba 二尺巾 75 cm: sweets or gift boxes and event gifts such as wedding presents.

- Nishi-Haba 二四巾 91 cm: two wine bottles, large sake bottle and for use as a shopping bag.

- Mi-Haba 三巾 102 cm: cushion cover, for organizing and carrying clothes and for use as a shopping bag.

- Yo-Haba 四巾 136 cm: large cushion covers and to bundle items for storage.

- Itsu-Haba 五巾 180 cm: bundling items for storage and goods for trade transportation.

- Mu-Haba 六巾 204 cm: can wrap one Futon set (Futon, pillow and duvet). Also used for bundling items for storage and goods for trade transportation and to use as a rug.

- Nana-Haba 七巾 238 cm: can wrap one Futon set. Also used for bundling items for storage and goods for trade transportation and moving house.

Furoshiki sizes are displayed in the unit of 'Haba' 巾, which, in Japanese, means 'width'. This expression of measurement derived from the width of a roll of cloth, was universally used until the beginning of the Meiji Period (1868-1912). Although the metric system was then adapted, Furoshiki manufacturers still use the Haba 巾 measurement for their trade.

The standard width of a roll of cloth is about 34cm, which means one Haba 巾 is 34cm and two Haba are 巾 68cm. Smaller pieces of cloth were sewn together to create a larger piece of Furoshiki until around 1955. The introduction of larger weaving machines made it possible to produce large Furoshiki in one piece, up to Yo-Haba 四巾 136cm size.

However, the modern Furoshiki has many different sizes beyond the standard sizes mentioned above.

FUROSHIKI DESIGN

The colour and composition of design affects the way Furoshiki looks. Traditionally, the composition of Furoshiki designs considered how it would appear both when wrapping items and unwrapping them. There are a few things you could consider when choosing a Furoshiki for wrapping your gifts. The first one is the relationship of sizes, volume and weight between a Furoshiki and an item. The next one is to imagine how it looks both when you wrap your gift and unwrap the gift. Do the colours of Furoshiki and the gift go well together? Does the Furoshiki design add more to your present? Does the Furoshiki echo your personality and taste? When you start to wrap a gift, try a few test wrappings to see how the design looks depending on how you position the Furoshiki at the beginning.

Here are some simple diagrams of the elemental composition of Furoshiki design:

隅付け
Sumi-tsuke

市松取り
Shimatsu-tori

斜め取り
Naname-tori

丸取り
Maru-tori

四方にらみ
Shihou-nirami

Sumi-tsuke is a minimalist design and can feature a family crest, which would mainly used for ceremonial occasions. These designs are focused on patterns in the corner areas.

The patterns are visible on the top and the bottom when you wrap a gift. It also gives an attractive look when you make a bag.

額取り
Gaku-tori

枡取り
Masu-tori

菱取り
Hishi-tori

全面取り
Zenmen-tori

散し紋
Chirashi-mon

The framed design spreads across the Furoshiki surface. These designs also look good when a gift is unwrapped and can be used as a tablecloth, a cushion cover or a bag.

The same design pattern is visible when wrapping in any style. These are subtle design styles so that the colour and pattern add personality.

正羽取り
Shouha-tori

のし目取り
Noshime-tori

小巾右付け
Kohabamitsuke

絵画風
Kaiga-fu

出合い
Deai-tori

中付け
Naka-tuke

These design structures are also used for designs of Kimono and Obi (the traditional Japanese belt). They have a simple composition yet are effectively arranged to make wrapped gifts look appealing.

These designs look great when framed as an artwork, hence it is good to give this type of Furosohiki as a gift. Multi-functional fabric art has many different looks whenever and however you decide to use it.

DECLINE OF FUROSHIKI CULTURE

Furoshiki has a long history, however the number of chances to use it in everyday life in Japan significantly fell after the post-war period of rapid growth. The lifestyle of Japanese people has changed dramatically with Western influence and the effects of the consumerist society.

Food and everyday products were sold by weight without packaging in the past. People used to take a Furoshiki, wooden bottle, clay pot, wooden box and basket to the shops to carry goods back home – much like the rest of the world before plastic bags were widely used. The use of Furoshiki has faded since around the 1970s: with the distribution of plastic and paper bags, wrapping paper and luggage, it was no longer necessary to bring a Furoshiki on the weekly shop. Although the use of Furoshiki continued in formal ceremonies such as weddings and funerals, Furoshiki was considered to be old-fashioned and too much effort.

FUROSHIKI REVIVAL

Furoshiki can be a reminder for us to review how we think about our belongings and waste, as well as to encourage us to behave responsibly towards our environment.

The increased number of innovative and bold designs of Furoshiki encourage the young generation to apply Furoshiki use in many modern ways. Endless colours are available for Furoshiki design. Even though the beauty of Furoshiki is that it does not need handles, there are leather and bamboo ring handles that you can tie to Furoshiki to make appealing bags. But Furoshiki can adapt to any shape and become useful without any additional add-ons. For this reason, you only need your creativity and a piece of cloth to try out various wrapping styles.

THE JOY OF FUROSHIKI

I hope that this book inspires many people to appreciate how versatile a piece of cloth can be, and that it activates conscious living and spreads the Furoshiki culture to the world.

More people are adapting their lifestyle to reduce waste and be more sustainable. Perhaps we could consider how we gift, and think about our environmental impact whenever giving a gift to someone, asking these two questions: Are we giving a gift from our heart and with joy? Are we producing more waste? This is the perfect time to start making a difference towards a better future. From this book, discover beautiful and fascinating ways to wrap a bottle of wine, bouquet or homemade dessert for a dinner party, wrap a book lover's birthday present or style up your reusable cup. Let Furoshiki culture inspire you to live a less wasteful and a more joyful life.

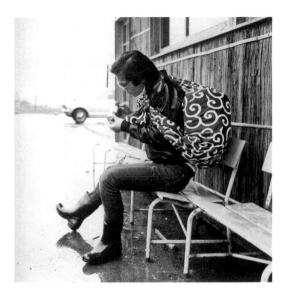

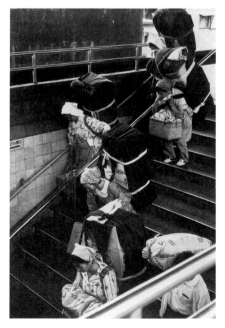

BASIC
KNOTS

There are a few key knots that are used repeatedly in Furoshiki: the square knot and the single knot. As with all the knot instructions in this book, you can also follow along using the videos accessed by the link on page 144.

SQUARE
KNOT

真結び

The 'Mamusubi' square knot is the most important knot for Furoshiki wrapping. It is important to master this knot before starting to learn the wrapping techniques. A useful feature of the square knot is that, once it's tied, it will never come loose, but it is still quick and easy to untie.

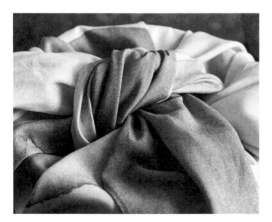

A B

一

Cross the ends over
and make sure that B is
on the top.

二

Loop B over piece A.

三

Take B to the left.

四

Swap hands and pull up A.

五

Bring A down towards you.

六

Pull A through the
loop made by B.

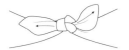

七

Pull both ends to tighten
the knot.

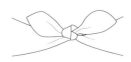

八

Now arrange the knot
to make it look more
attractive. You can fan out
the ends as well.

TIP:
The tied ends of the square
knot should lie horizontally.
If they end up vertical, you
have created a 'Tatemusubi'
granny knot, which is
not used for Furoshiki
wrapping.

HOW TO UNTIE
A SQUARE KNOT

B A

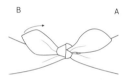 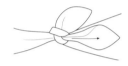

—

Place your square knot
'Mamusubi' so it is
straight on, with each
end horizontal.

二

Take B and pull it over
towards A until it is
in a straight line.
(The other end will
move slightly horizontally
but this is OK.)

三

Grasp the knot from A
and slide it to the right,
holding on to B with your
other hand.

四

You should be able to slide
the end B through the knot
A without pulling too much.

五

Now the ends should be
separate. It is untied!

SINGLE
KNOT
一つ結び

The 'Hitotsumusubi' single knot is another important knot for Furoshiki wrapping. It is a simple knot for adjusting the size of the Furoshiki to match what is being wrapped. Where to place the knot is entirely up to you. Once you master how to use this knot effectively, it will make using Furoshiki much simpler and you will be able to easily adjust it to different-sized content.

—

Fold the material over so the edges are tucked away.

二

Pick up and make a loop.

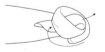

三

Now take the end and pull it through the loop.

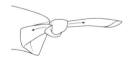

四

Now pull both ends of the material to create a knot.

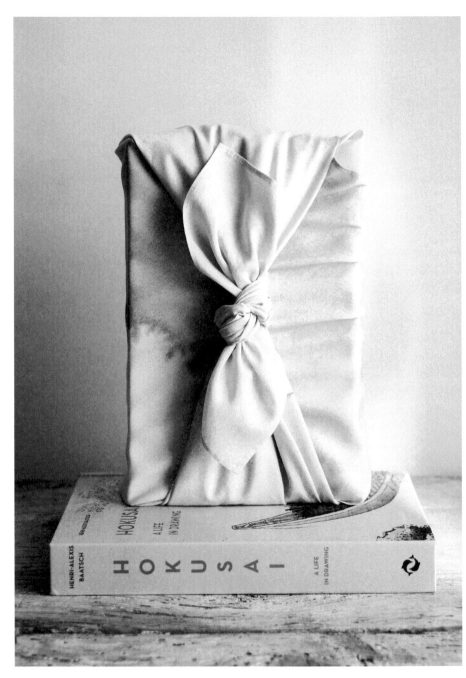

EVERYDAY
WRAP
お使い包み

This is the most usual way to wrap a box-shaped object with Furoshiki. The diagonal length of the Furoshiki should be about three times the length of the object. Furoshiki wrapping looks best with tidy corners and as few wrinkles in the material as possible. You can also check how the design of the material will show when the object is wrapped before you start wrapping.

一

Put your Furoshiki on the diagonal with the design side facing down. Place the object you wish to wrap in the centre.

二

Fold the bottom corner over the object and tuck it under.

三

Now fold the top corner over the object and tuck the end under the object if you have any excess fabric.

四

Fold the left corners together and make sure they are nice and tidy.

五

Fold the left corner over the object.

六

Now repeat with the right corner, making sure the corners are sharp and tidy again.

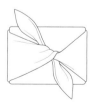

七

Tie the left and right corners together.

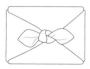

八

Use the square knot (see page 14) to tie the ends.

九

Adjust the material and knots to make sure it's not wrinkled and is neat and tidy.

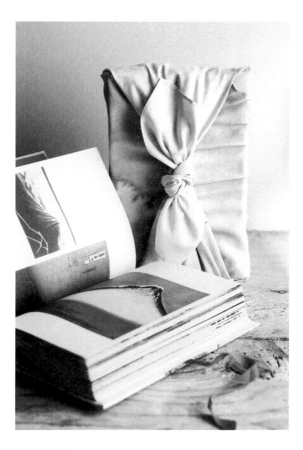

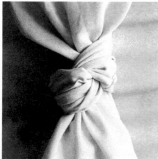

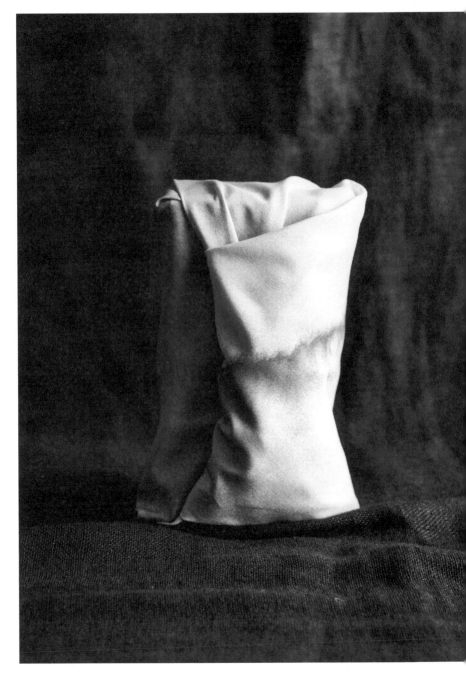

HIDDEN
KNOT WRAP

かくし包み

In Japan, this is considered to be a more formal wrap because the knot is neatly hidden away. You can also insert a card with a message or a flower in the pocket. By adding a little touch like this to an everyday wrap, it looks more elegant. This style keeps the shape well and is easy to carry around.

一

Put your Furoshiki on the diagonal with the design side facing down. Place the object you wish to wrap in the centre, above the imaginary line connecting the left and right corners.

二

Bring the bottom corner up to the top to make a triangle.

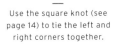

三

Use the square knot (see page 14) to tie the left and right corners together.

四

Now fold the top corners over the knot and tuck them under so the knot is hidden.

五

Adjust the material and knots to make sure it's not wrinkled and is neat and tidy.

TIP:

Tuck a message card or flower in the pocket.

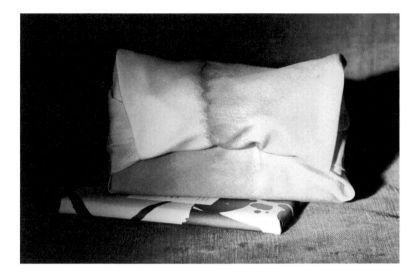

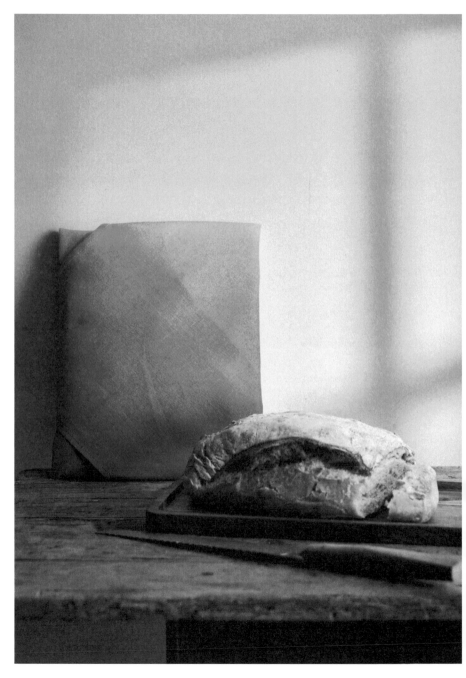

FORMAL
FLAT
WRAP
平包み

The basic method of using Furoshiki for every-day life is based on tying knots. However, for formal occasions such as a wedding, we use the Flat Wrap method which doesn't use any knots. Naturally, when giving a knotted Furoshiki it must be untied, but by eliminating the knots you provide a metaphor of a good relationship: it is never disconnected.

一

Put your Furoshiki on the diagonal with the design side facing down. Place the object you wish to wrap in the centre, above the imaginary line connecting the left and right corners.

二

Bring the corner at the bottom up to the top to make a triangle.

三

Bring the left corner over the object, folding it carefully, following the lines of the object.

四

Tuck the end of the left corner underneath so the end is 'squared' off.

五

Bring the right corner over the object, folding it carefully, following the lines of the object.

六

Tuck the end of the right corner underneath so the end is 'squared' off.

七
Lift the top corner
and place any excess fabric
inside to make the
corners clean.

八
Cover the object by
bringing the material from
the top downward.

九
Finish by tucking the
end of the top corner
under the object.

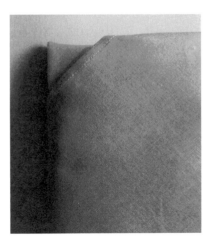

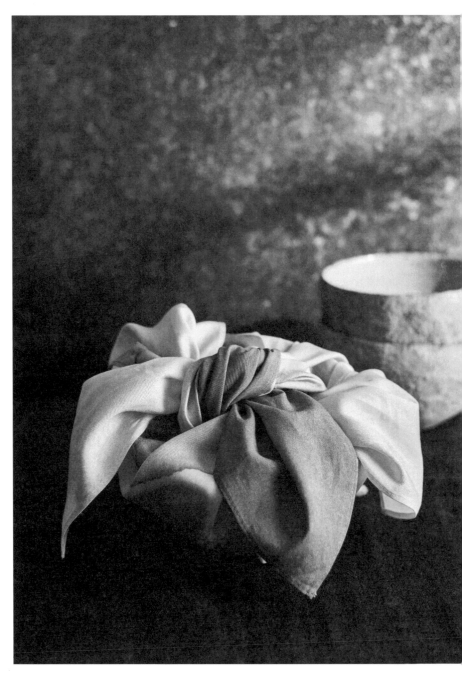

FLOWER
PETAL
WRAP

花びら包み

With this pretty style of Furoshiki, the four edges become like flower petals. This style can be used to wrap many different-shaped objects. It is also used for carrying heavy objects as the two firmly tied knots make a secure handle. This style of wrap will be enhanced by Furoshiki designs with patterns in the corner areas.

一

Lay your Furoshiki on the diagonal with the design side facing down. Place the object you wish to wrap in the centre.

二

Tie the left and right corners together.

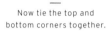

三

Now tie the top and bottom corners together.

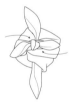

四

Tie the left and right corners with a square knot (see page 14) over the existing knot.

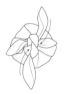

五

Now tie the top and bottom corners with a square knot over the knot.

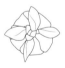

六

The ends should be short enough now to be neatly presented. Adjust the fabric and the knots to make it look nice.

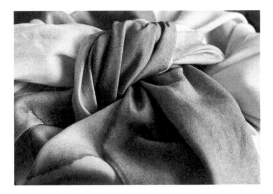

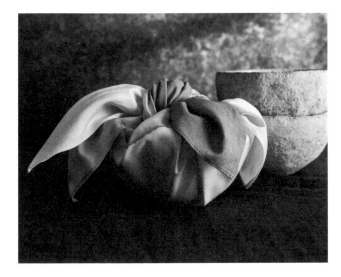

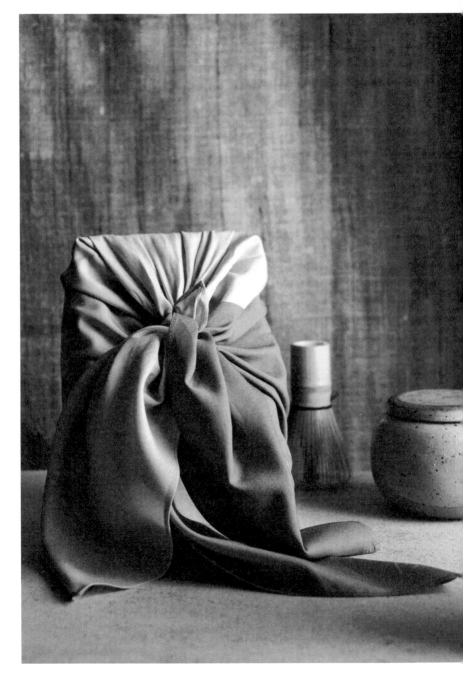

GATHERED
WRAP

寄せ包み

This method uses one of the sides of the Furo-shiki to tie the remaining three. It is a useful way to wrap various objects of different sizes. If you use a light, soft fabric you can create beautifully draped edges. You can achieve more of a sculptural look using firmer materials such as linen.

一

Lay your Furoshiki on the diagonal with the design side facing down. Place the object you wish to wrap in the centre.

二

Lift up the top and bottom corner together.

三

Now lift the left corner up and adjust the fabric around the object being wrapped. Grip the three corners as close to the object as possible.

四

Lift the right corner up tightly.

五

Loop the right corner around the base of three corners.

六

Push the end of the right corner from below through the loop you have created.

七

Pull up the end of the right corner and tighten.

八

Adjust the fabric to showcase the beautiful draped corners.

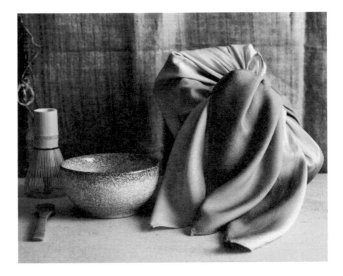

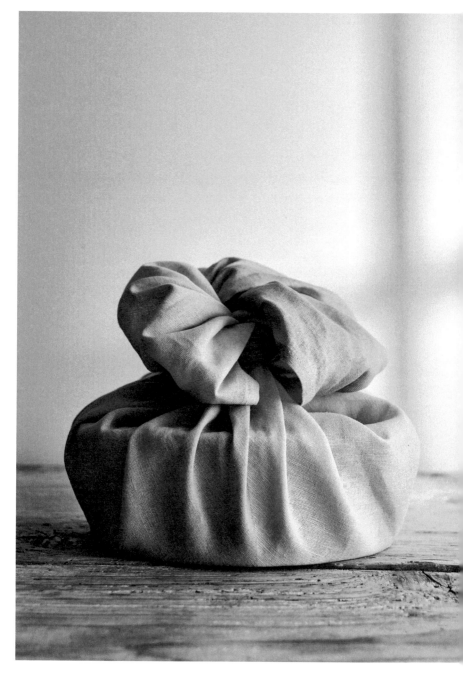

POM-POM
WRAP

ポンポン包み

This is a modified version of the bundle wrap. In this iteration, the ends are tucked under the loop and create light fabric balls. If you use a linen material this will give your Furoshiki more of a rustic and sculpted look.

一

Lay your Furoshiki on the diagonal with the design side facing down. Place the object you wish to wrap in the centre.

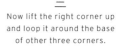

二

Lift the top, bottom and left corners up and adjust the fabric to fit snugly against the object you are wrapping.

三

Now lift the right corner up and loop it around the base of other three corners.

四

Push the end of the right corner from below through the loop you have created.

五

Tuck the ends of the other corners under the loop to create fabric balls.

六

Finish by adjusting the fabric and knots to make it look neat.

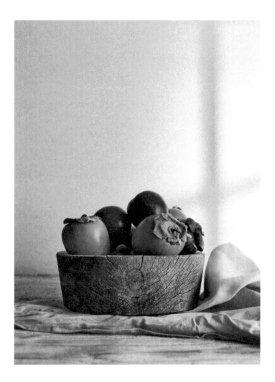

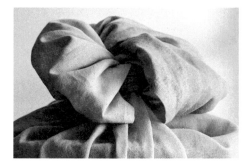

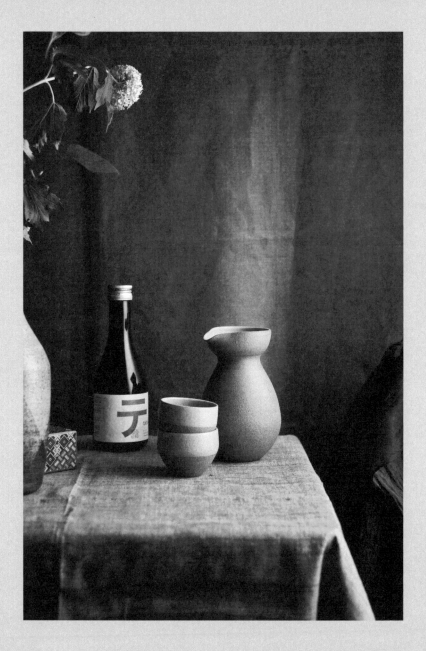

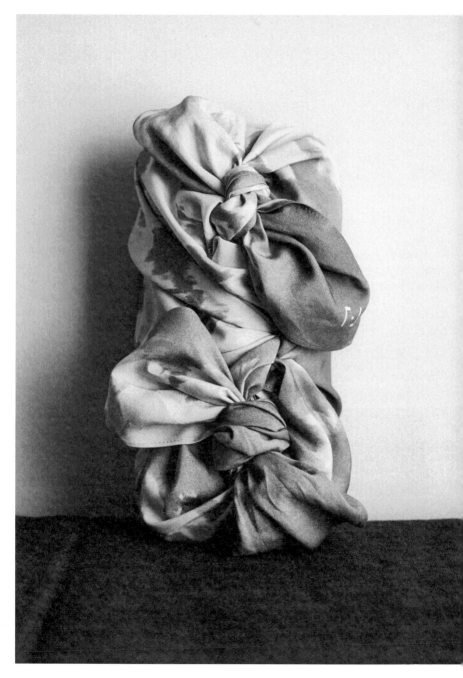

DOUBLE KNOT WRAP

二つ結び

This style works well for long thin objects. The Double Knot is convenient for wrapping items to which you might want frequent access, such as a basket of food or an open box of stationery items. Untie and re-tie only one end and you can have access to the contents without unwrapping the whole item.

一

Lay your Furoshiki on the
diagonal with the design
side facing down. Place the
object you wish to wrap
in the centre.

二

Tie the top and bottom
corners once. You will now
have two corners on the left
and two on the right.

三

Make a square knot (see
page 14) with the two
corners on the left.

四

Adjust the fabric and fan
out the ends.

五

Make a square knot with the
two corners on the right.

六

Finish by adjusting
the fabric and knots to
make it look neat.

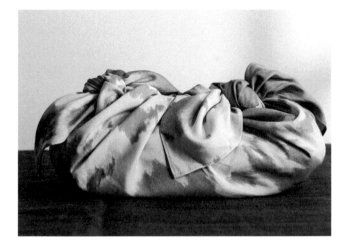

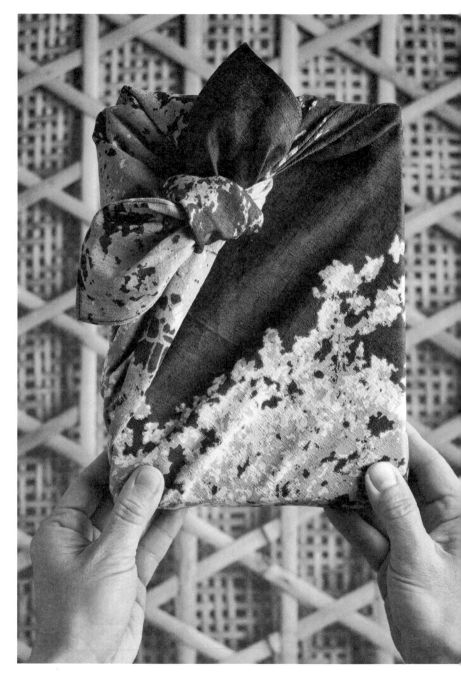

BOW
CORNER
WRAP
リボン包み

This is a useful way of wrapping flat and square objects. Books, picture frames and small flat boxes are the ideal gifts to be wrapped in this style. Adding a square knot on the corner will make the Furoshiki more special. The object needs to be placed carefully in order to make the presentation work.

—

Lay your Furoshiki on the diagonal with the design side facing down. Align the top right corner of the object you wish to wrap at the centre of the right top side of the Furoshiki.

Allow about the thickness of the object you are wrapping plus 3 cm from the edge.

二

Flip the object once towards you.

三

Fold the bottom corner over the object. Tuck any excess fabric under the object.

四

Fold the left corner tightly over the object.

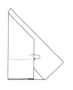

五

Tuck the fabric under the left corner neatly.

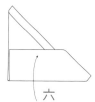

六

Fold the whole of the object being wrapped towards the top corner.

七

Fold the perpendicular
side over to create a long
edge ready to tie.

八

Fasten with a square knot
(see page 14).

九

Finish by adjusting
the fabric and knots to
make it neat.

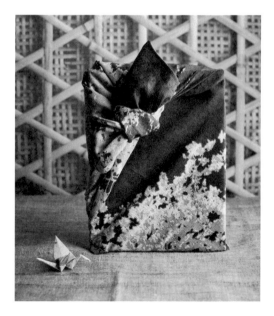

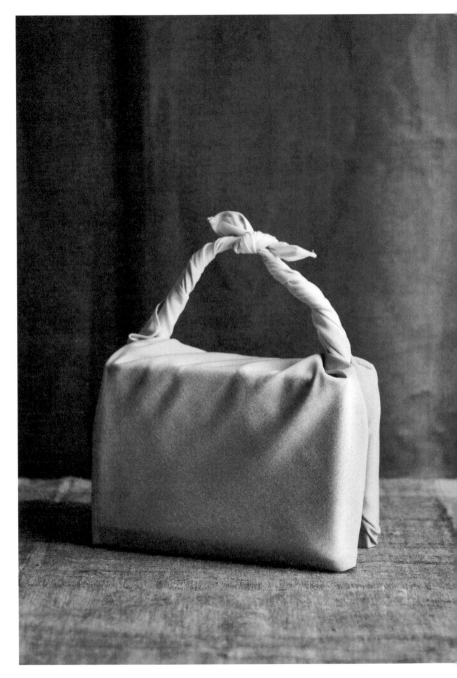

TWIN
WRAP
双子包み

You can use this method to wrap two objects of similar size and shape. The small handle is useful for carrying the objects. By selecting a Furoshiki with two sets of diagonal corners in different colours you can create a contrasting handle to the rest of the wrap.

一

Lay your Furoshiki on the diagonal with the design side facing down. Place two books or note books of similar size in the centre.

二

Flip the book closest to you once towards the bottom corner.

三

Flip the other book once towards the top corner.

四

Fold the bottom corner over the bottom book.

五

Fold over one more time.

六

Fold the top corner over the top book and fold over one more time.

七

Twist the right and left corners.

八

Cross the corners over and swap hands.

九

Take the book closest to you and fold over onto the other book.

Twist the corner ends
to become a handle.

Make a small square knot
(see page 14) to fasten.
Carry the books by holding
the handle.

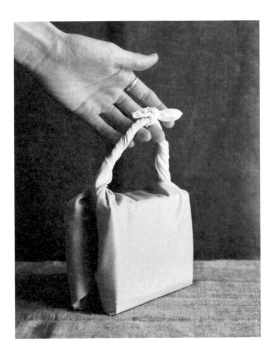

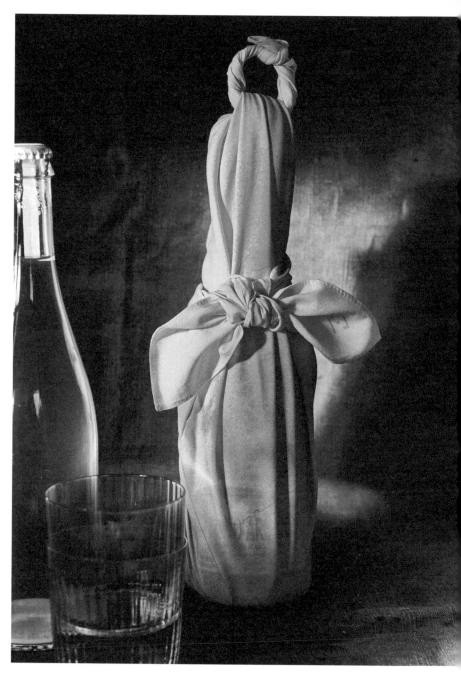

GATHERED
BOTTLE
WRAP

寄せ瓶包み

A small circular handle is convenient for carrying a bottle. You can also make a knot on the top of the bottle without creating a small handle. This method is a common way of wrapping a bottle as a gift in Japan.

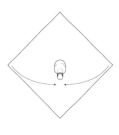

一

Lay your Furoshiki on the diagonal with the design side facing down. Stand a bottle in the centre.

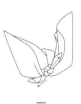

二

Using two opposite corners tie a square knot (see page 14) at the top of the bottle

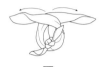

三

Cross the other two corners around the object.

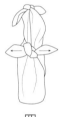

四

Lay the object down and make a square knot to fasten.

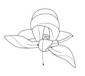

五

Untie the knot once at the top of the bottle.

六

Twist the ends of the fabric to make a handle.

七

Finish off with a small square knot.

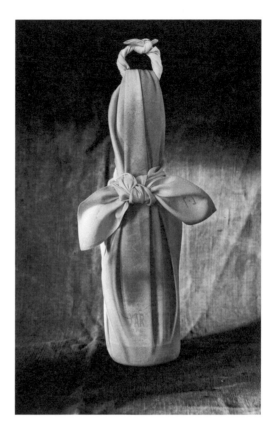

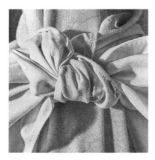

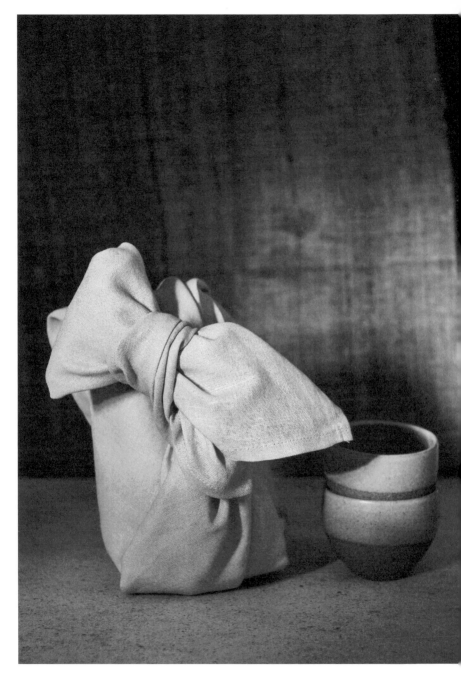

BOW
BOTTLE
WRAP
ネクタイ瓶包み

This Furoshiki has a big bow, which gives the gift a bold appearance. If you use linen fabric you'll find it adds a sharp and more sculpted look. If you use lighter fabric you can play with the draped bow shape, which will give more delicate and softer look.

一

Lay your Furoshiki on the
diagonal with the design
side facing down. Place the
object you wish to wrap in
the centre.

二

Roll the the bottom corner
around the object and up
towards the top corner.

三

Fold the left and right
corners to the front,
tucking under the tip of the
top corner so it's covered.

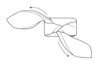

四

Tie the corners once.

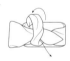

五

Make a big fold with one
corner and fasten it with
the other corner – it should
look like half a bow.

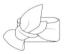

六

Adjust the fabric and
bow to make a neat parcel.

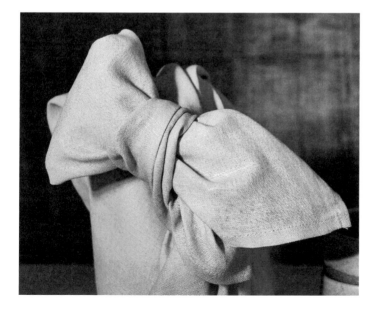

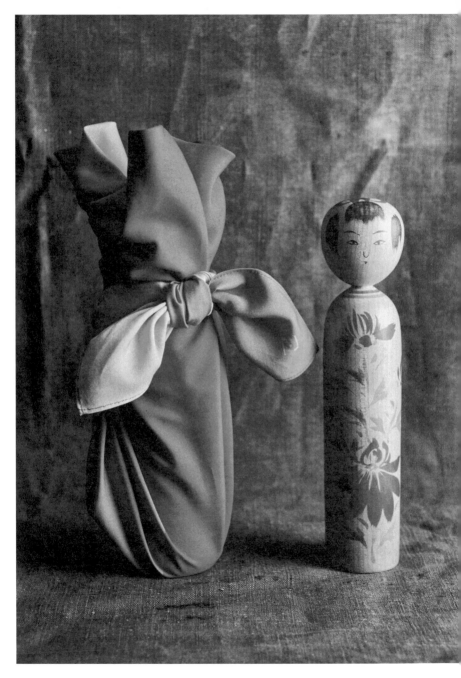

PLEATED
BOTTLE
WRAP
プリーツ瓶包み

This style is suitable for long thin objects.
Select a soft fabric for an elegant draping effect.
You can use rubber bands to make it easier to
hold the gathered fabric. Adding more pleats
will make them appear crisper, and therefore
give you a fancier look, and fewer pleats will
create a softer look.

一

Lay your Furoshiki on the diagonal with the design side facing down. Stand the object you wish to wrap in the centre.

二

Bring up the bottom corner and fold over the material to line up with the top of the object. Lay it back down.

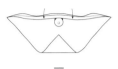

三

Bring up the top corner and fold over the material to line up with the top of the object.

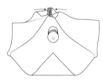

四

Pleat the material so it gathers together.

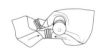

五

Keep holding the pleated top material and pick up the folded bottom corner and pleat that in the same way.

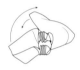

六

Hold the pleated corners with one hand, or you could use a rubber band to hold them. Cross the right and the left corners behind the object.

七

Lay the object down and fasten with a square knot (see page 14). Adjust the fabric and fan out the pleating to present it nicely.

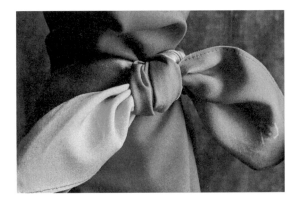

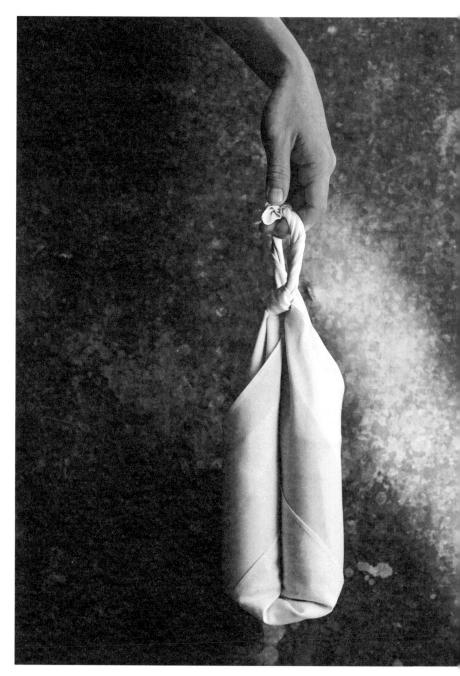

PAIRED
WRAP

合わせ包み

This is a method for wrapping two objects of a similar size. The handle makes it easier to carry. You can wrap bottles, books, boxes and even fruit using this style.

一

Lay your Furoshiki on the diagonal with the design side facing down and place the two objects you wish to wrap in the centre, about the width of the objects apart.

二

Fold up the bottom corner to make a triangular shape.

三

Fold the Furoshiki over the object and roll up towards the top corner.

四

When you reach the top corner, stand the two objects up.

五

Pull the the right and the left corners up and tie once.

六

Twist the fabric of the two corners to make a handle.

七

Make a small loop and tie.

八

Use a small square knot (see page 14) to fasten.

九

The objects can be carried with this handle.

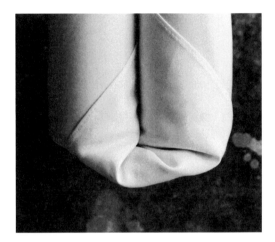

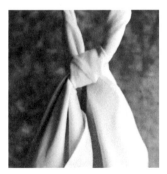

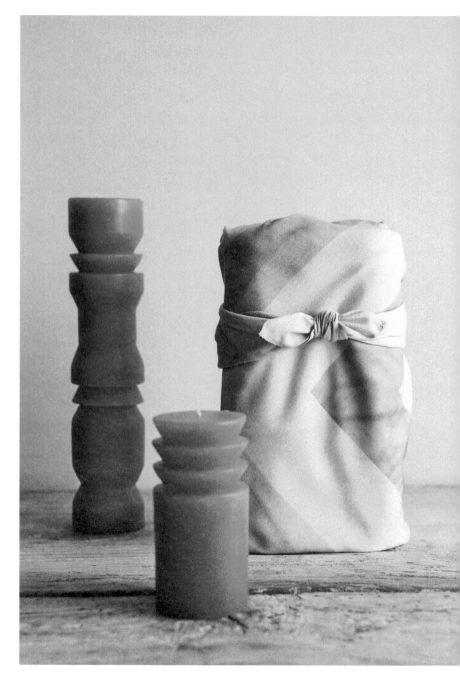

POLE-AND-LOOP
WRAP

棹包み

This method is also called 'Sao Tsutsumi'. 'Sao'
棹 means 'pole' and 'Tsutsumi' 包 means 'wrap'
in Japanese. People used to carry items wrapped
in this style and put a pole through the tied loop.

一

Lay your Furoshiki on the diagonal with the design side facing down and place two objects just below the centre.

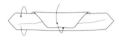

二

Fold up the bottom corner to make a triangular shape.

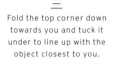

三

Fold the top corner down towards you and tuck it under to line up with the object closest to you.

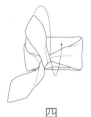

四

Take the right and the left corners up and cross over with a knot so it's slightly off-centre.

五

Turn the object around so the knot is nearest to the bottom.

六

Make a square knot (see page 14) to fasten and adjust the fabric and knots to make it look neat.

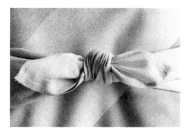

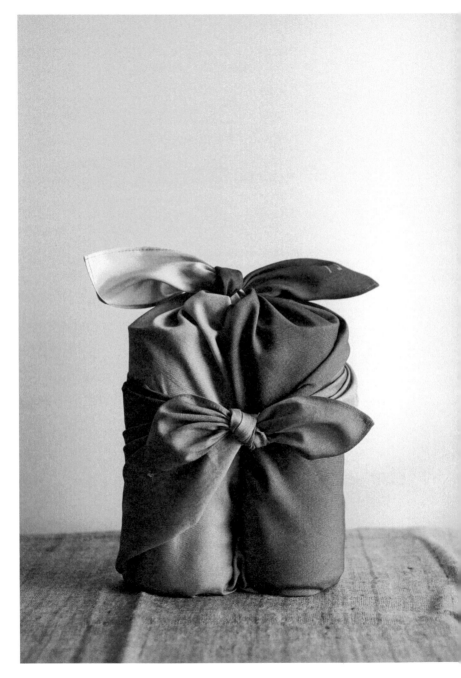

FANCY
WRAP

華やか包み

This method uses two knots and makes the Furoshiki look more luxurious. It is easy to carry holding the knot on the top. The wrap looks best when two similar-sized objects are used.

一

Lay your Furoshiki on the
diagonal with the design
side facing down and place
two similar-sized objects
in the centre.

二

Fold up the bottom corner
to make a triangular shape.

三

Bring the two objects
up so they are standing.

四

Make a square knot (see
page 14) with the two
corners on top of the
objects.

五

Take the other corners
and cross them over so they
go round the back of
the objects.

六

Make a square knot at
the front of the objects.
Adjust the fabric and knots
to make them look neat.

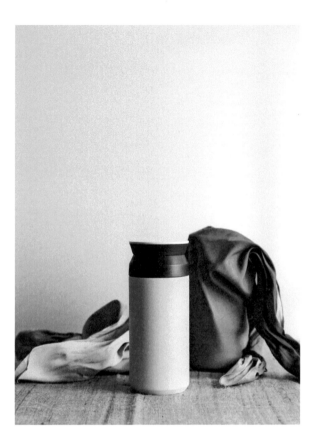

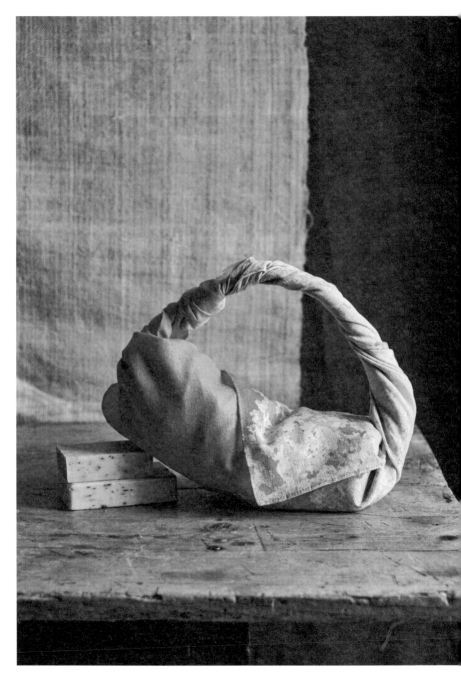

BANANA WRAP
バナナ包み

This method is used to wrap odd-shaped
objects, like bananas, or to bundle small things
together. It can also be used as a cosmetics bag
to organize smaller items inside your larger bag.

一

Lay your Furoshiki on the diagonal with the design side facing down. Place the objects you wish to wrap in the centre slightly on the left side.

二

Fold the bottom corner up and start rolling the objects towards the top corner.

三

Roll it completely to the top corner.

四

Twist the fabric of the right corner.

五

Twist the fabric of the left corner.

六

Make a square knot (see page 14) to fasten. Adjust the fabric and knots to make it look neat.

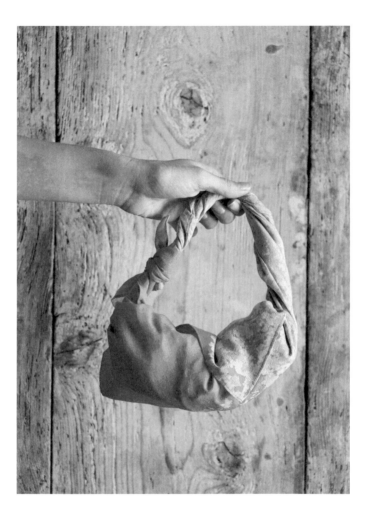

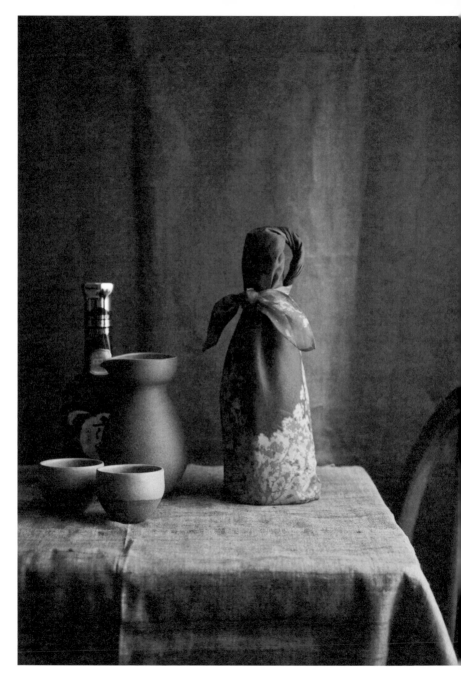

FINGER
LOOP
WRAP
指輪包み

This method of Furoshiki wrapping creates a small finger handle. It is a convenient way to carry a bottle when you are going to a dinner party. And the wrap makes your gift to the host extra special.

一

Lay your Furoshiki on the diagonal with the design side facing down. Place the object you wish to wrap slightly on the left side.

二

Fold the bottom corner up and start rolling the object towards the top corner.

三

Roll completely to the top corner.

四

Hold the right corner firmly and pull up.

五

Fold the right corner over the object.

六

Take up the left corner.

七

Twist the left corner to prepare for the handle.

八

Cross the right and the left corners over one another and then around the bottle neck.

九

Turn the bottle and tie both corners once.

+

Finish with a small square knot (see page 14).

+ —

You can now carry the object with the handle.

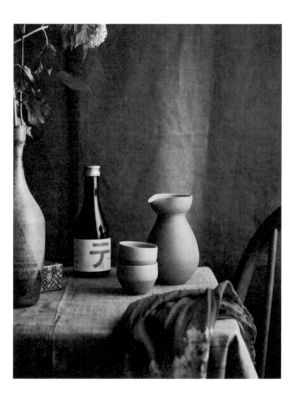

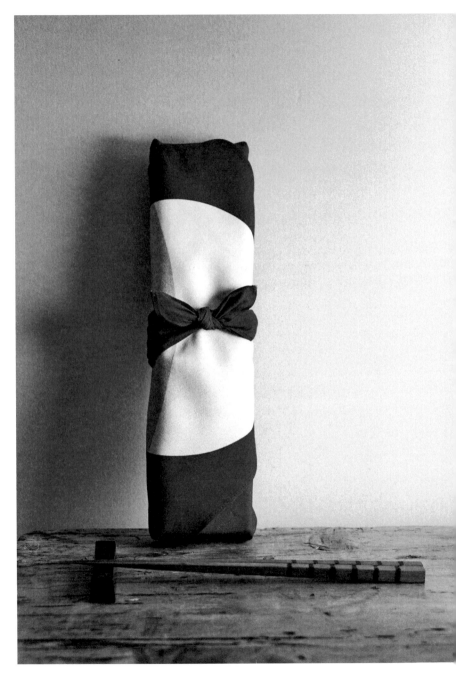

ROLLED
WRAP

巻包み

This wrap has a very simple and clean look. You can wrap your object without tying knots to first check how the Furoshiki design will appear and adjust if necessary. You can create different impressions depending on the pattern of Furoshiki.

一

Lay your Furoshiki on the diagonal with the design side facing down. Place the object you wish to wrap just above the centre.

二

Fold the bottom corner up and start rolling the object towards the top corner.

三

Roll up tightly to fit the shape of the object all the way to the top corner.

四

Turn the object over and pull the right and left corners together tightly.

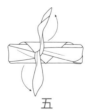

五

Cross the two corners.

六

Turn the object back over and make a square knot (see page 14) on the front. Adjust the fabric and knots to make it neat.

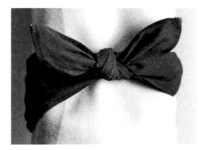

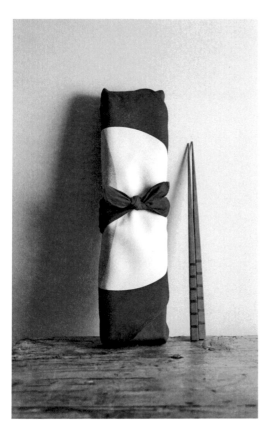

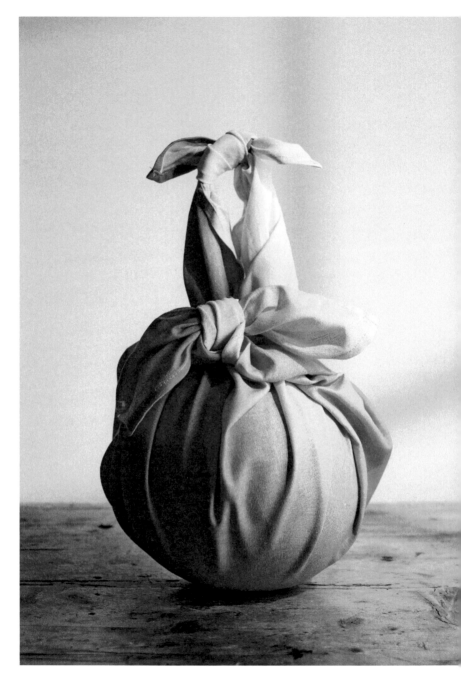

WATERMELON
WRAP

すいか包み

This wrap is not only for watermelons but also for any odd-shaped objects you want to carry. Watermelon is a popular fruit in Japan. This wrapping method was used regularly when there were no plastic shopping bags.

一

Lay your Furoshiki square, with the design side facing down. Bring the two bottom corners together and tie once.

二

Fasten the two corners with a large square knot (see page 14).

三

Bring the top two corners together and tie them with a small square knot.

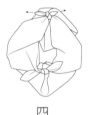

四

Use the smaller knot from the top corners for the side that will be the handle.

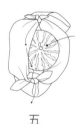

五

Put an object in the wrapping bag and pull the small knot through the space under the large knot.

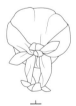

六

Adjust the fabric and knots to make it neater.

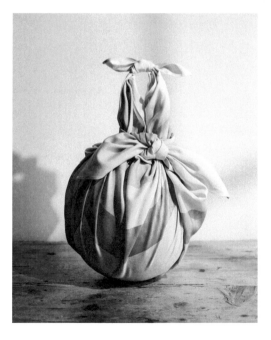

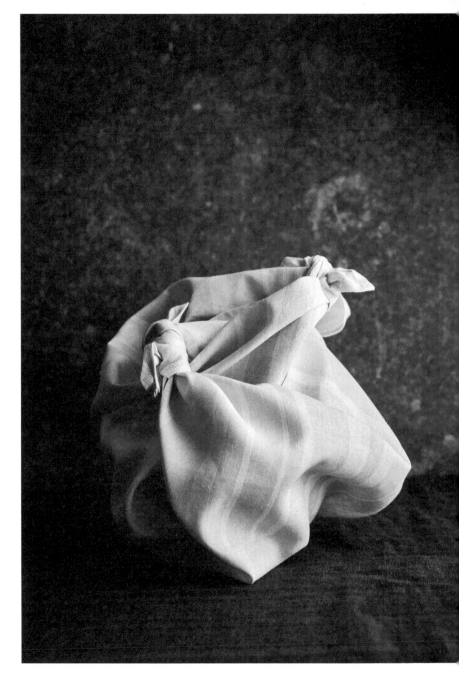

DOUBLE
HANDLE
WRAP
二重取っ手包み

This is another method to carry a watermelon and other weightier, odd-shaped objects. The two handles are crossed over each other so this wrap has very strong and stable handles. You can use this for wrapping and carrying a gift and also as a shopping bag, too.

一

Lay your Furoshiki with the design side facing down. Place the object you wish to wrap in the centre.

二

Bring the two bottom corners together.

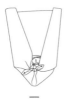

三

Fasten them with a small square knot (see page 14).

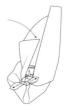

四

Pull the top left corner up.

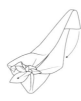

五

Pull it under the small knot.

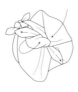

六

Pull the top right corner up and tie it to the corner that was pulled through the small knot.

七

Fasten the top corners with a square knot.

八

Adjust the fabric and knots to make it neat.

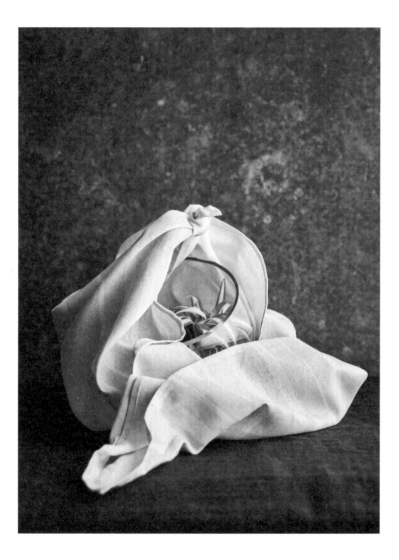

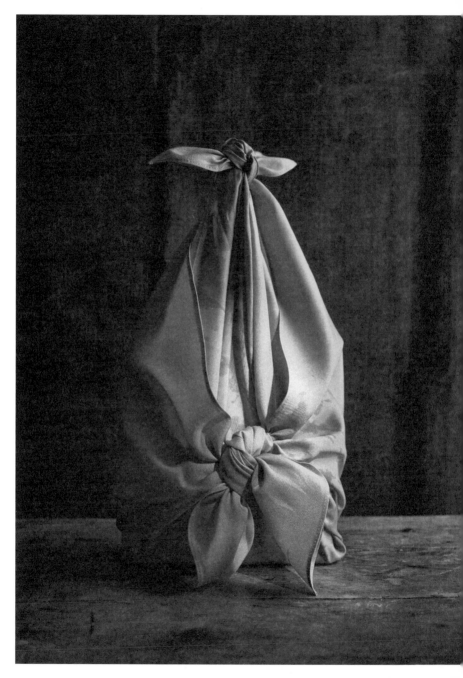

BOOK
BAG
WRAP
本手提げ包み

This wrap is called a lesson bag. It is a convenient way to carry textbooks and notebooks, which you can access without untying the knots. The large knot on the front adds an elegant look.

一

Lay your Furoshiki on the diagonal with the design side facing down. Place the object you wish to wrap above the diagonal line

二

Fold the bottom corner up to the top corner to make a triangular shape.

三

Tie the left and the right corners once.

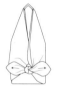

四

Fasten with a square knot (see page 14).

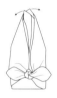

五

Take the top of the two corners.

六

Pull the two corners apart slightly.

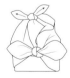

七

Use a small square knot at the top of the fabric to make a handle.

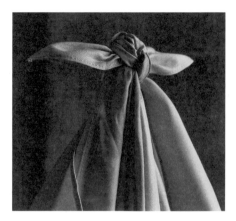

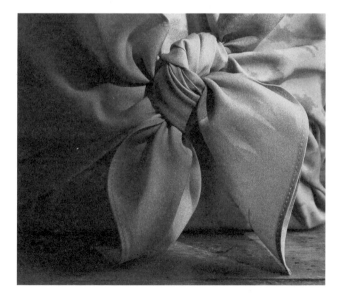

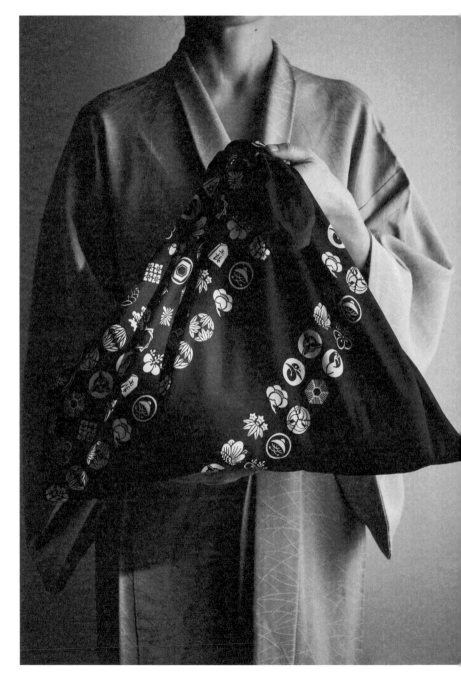

TOTE
BAG
WRAP

運び手提げ包み

This is an easy and commonly used method to wrap objects so you can carry them. A large Furoshiki could be used to carry clothes to go to a bathhouse, or a small Furoshiki could be used to wrap a lunch box, with lots of other uses as well.

一

Lay your Furoshiki on the diagonal with the design side facing down. Place the object you wish to wrap in the centre

二

Fasten the right and left corner using a square knot (see page 14).

三

Pull the top and the bottom corners up.

四

Fasten the top and bottom corners by using a square knot.

五

Use the handle created to carry the object.

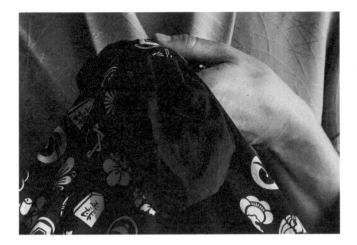

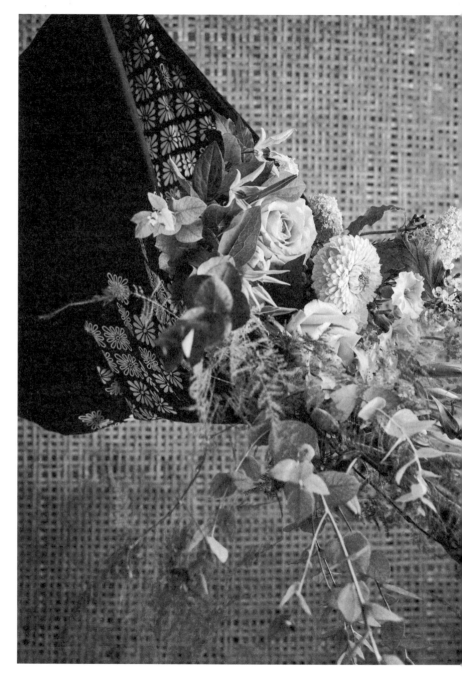

BOUQUET
WRAP

花束包み

With this style of wrap, not only will your bouquet look great, but it can be carried really easily. You can position the single knots on the two ends depending on the size of the objects you're wrapping.

—

Lay your Furoshiki on the diagonal with the design side facing down. Make a single knot (see page 17) with the right corner.

二

Make a single knot with the left corner.

三

Lay the bouquet across the Furoshiki so that the left and right corners now appear at the top and bottom of the bouquet.

四

Make a square knot (see page 14) with the two remaining corners to form a handle.

五

Adjust the fabric and knots to make it neater.

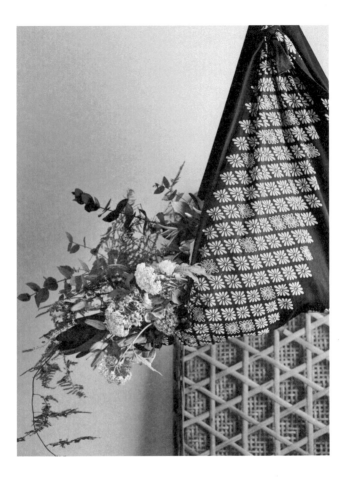

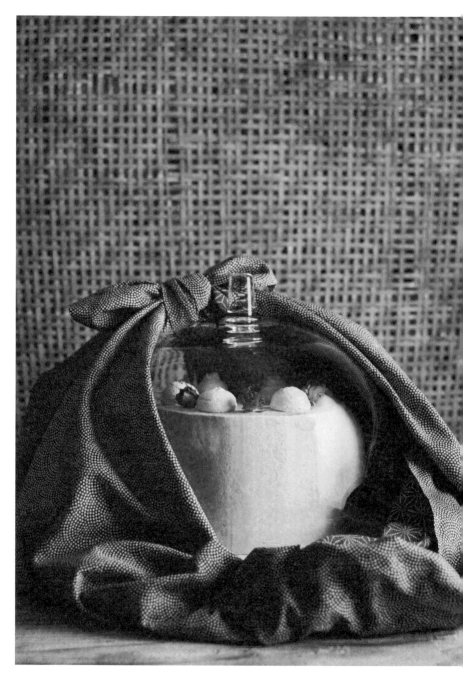

SIMPLE
DROP
BAG

簡単ドロップバッグ

In this method, the two knots are tucked inside the bag to make it look neater. In Japan, we use this method to carry sushi, food, cakes and many more things. It is very easy and quick to make this bag, which makes it a good everyday option.

一

Lay your Furoshiki on the diagonal with the design side facing up. Make a single knot (see page 17) with the right corner.

二

Make a single knot with the left corner.

三

Turn the Furoshiki over so the design side is facing down.

四

Place the object you want to carry in the middle.

五

Cross over the two remaining corners.

六

Fasten the corners with a square knot (see page 14).

七

Use the handle created to carry the object.

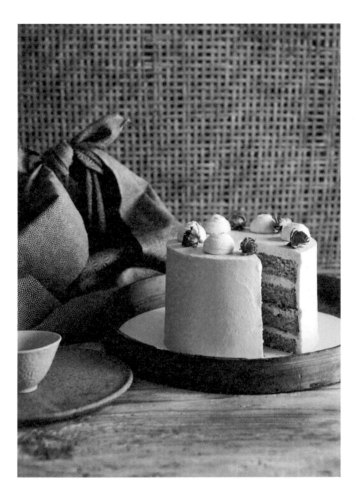

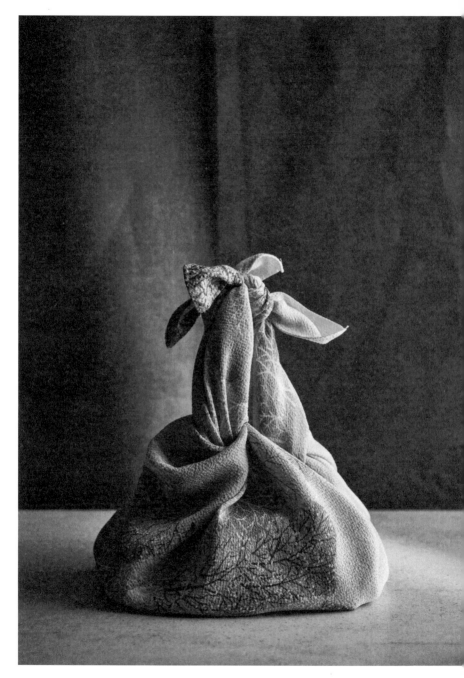

BASKET
WRAP
バスケット包み

This is a method that can make a small bag when closed or a basket when opened. It opens and closes easily when you pull the two handles. It's a great wrap to organize items inside a larger bag or a travel bag.

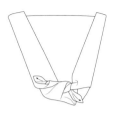

一

Lay your Furoshiki with the design side facing down and tie the two bottom corners once.

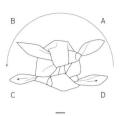

二

Turn the Furoshiki 180 degrees and tie the other two corners once.

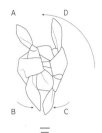

三

Turn the Furoshiki 90 degrees and tie corner B and corner C.

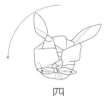

四

Fasten the corners with a square knot (see page 14).

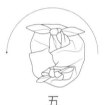

五

Make a square knot with the other two corners (A and D).

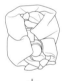

六

Place the objects you wish to carry in the bag.

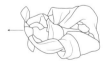

七

Pull one of the handles up.

八

Pull the other handle up to close the basket.

九

The basket will now turn into a bag with handles.

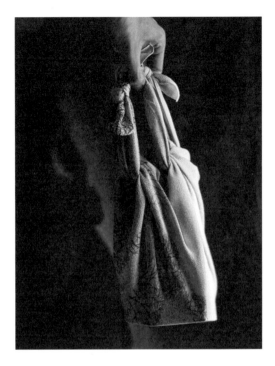

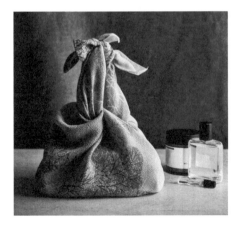

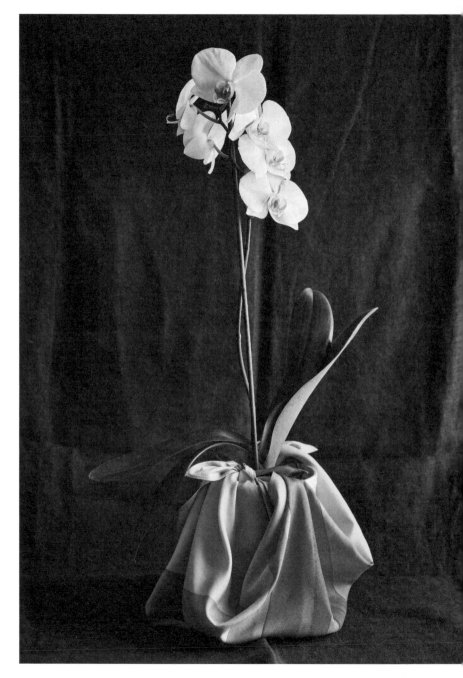

ORCHID
WRAP

蘭包み

When you are giving a plant, this is an easy way to present the gift in a beautiful way. The wrap also has two handles to make it easier to carry. This method is so simple and quick to make. It is a great alternative to any sort of gift wrapping.

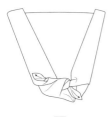

—

Lay your Furoshiki with the
design side facing down.
Bring the two bottom
corners together.

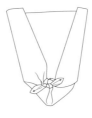

二

Use a square knot
(see page 14) to fasten
the two corners.

三

Turn the Furoshiki
around and use another
square knot to fasten the
remaining corners.

四

Adjust the fabric and
knots to make it neat.

五

Place the object you wish to
carry or wrap in the bag.

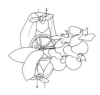

六

Carry the object with
the two handles.

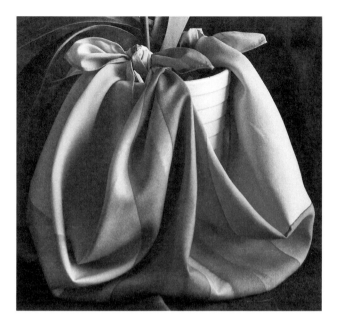

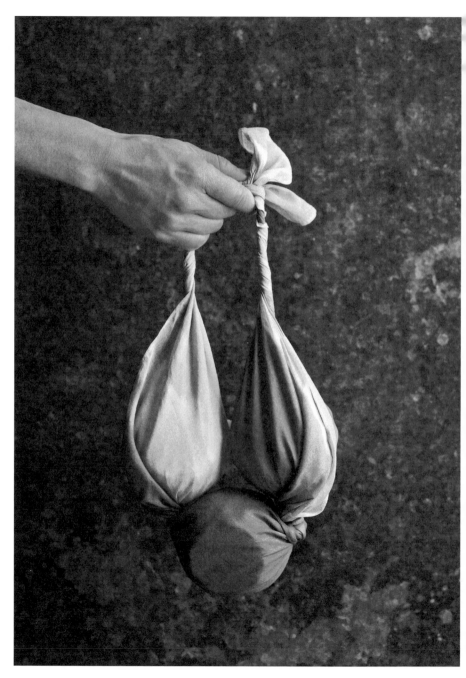

This is a good method to wrap objects of a similar size. A handle will make it easier to carry the objects. The number of objects can be anything depending on the size of Furoshiki and the size of objects. This method shows how versatile Furoshiki can be!

一

Lay your Furoshiki on the diagonal with the design side facing down and place three objects of the same size in the centre, about 5 cm apart.

二

Fold the bottom corner to the top corner to make a triangle.

三

Fold the top corner over the objects and roll them upwards, tucking the fabric underneath.

四

Twist the object on the right twice.

五

Twist the object on the left twice.

六

Pull the right and left corners of the fabric together.

七

Twist the right and left corners to make a handle.

八

Make a small square knot (see page 14) to fasten.

九

Carry the objects with the handle.

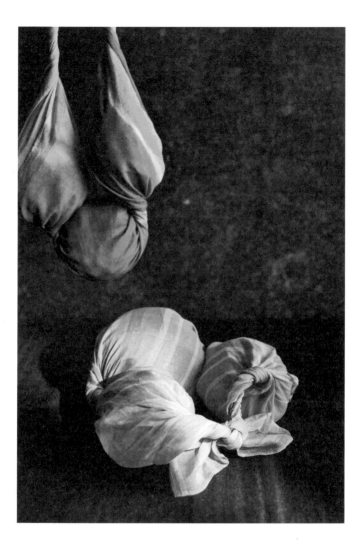

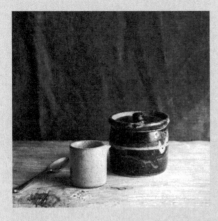

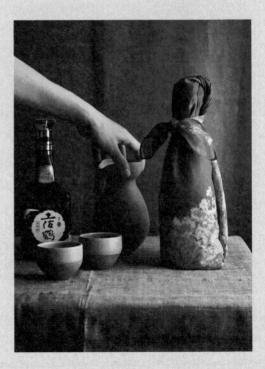

RITUAL
WRAP
ふくさ包み

This method is still used to wrap envelopes gifting money at weddings and funerals in Japan. A special small Furoshiki called 'Fukusa' is used for these occasions. Fukusa is usually pure silk as it is considered the most formal and elegant material for Furoshiki. We used linen for this wrap to give warmth and natural texture, and to add a kind and pleasant feeling. It is useful to know that we do every step of wrapping using opposites (left and right, top and bottom) for solemn occasions in Japan.

一

Lay your Furoshiki on the diagonal with the design side facing down and place an envelope to the edges of the right corner.

二

Turn the envelope once towards the left corner.

三

Fold the left corner over the envelope and tuck the excess fabric under the envelope.

四

Place the top corner over the envelope.

五

Place the bottom corner over the envelope.

六

Place the right corner over the envelope.

七

Finish by tucking any extra fabric underneath.

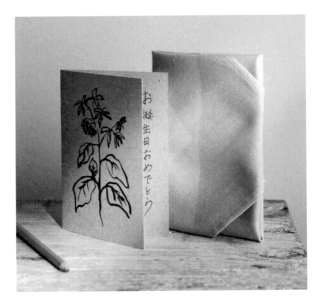

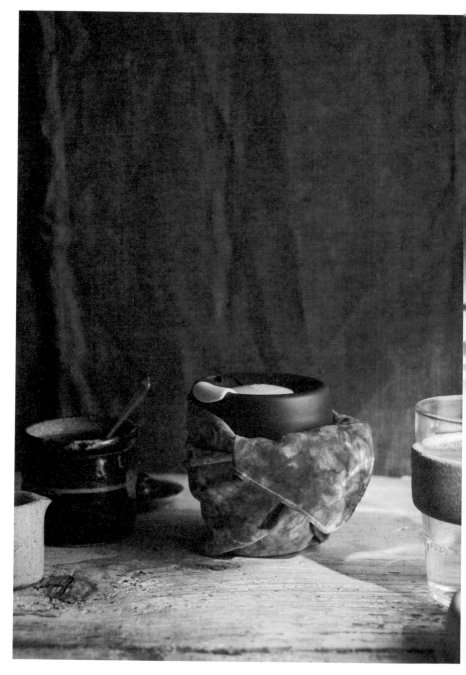

CRADLE
WRAP
ゆりかご包み

This is a nice way to wrap a cup or a mug as a gift. You can use this method for any type of cup. It can even be used for wrapping small plant pots - you will just need to adjust the size of Furoshiki depending on the plant-pot size.

一

Lay your Furoshiki
on the diagonal with the
design side facing down.
Fold the top corner down
towards you.

二

Place the object you wish
to wrap in the centre of the
upside-down triangle.

三

Check the height of the
fabric and that it comes
up level to the top of
your object (use a larger
Furoshiki if this is
not the case).

四

Pull the bottom corner
up to the object.

五

Hold the top and bottom
side of the fabric against
the object with one hand.

六

Take the right corner
of the Furoshiki and bring it
to the front.

七

Hold the top and bottom
side of the fabric with
your hand. Now take the
left corner and bring that
to the front.

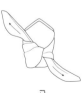

八

Tie the right and left
corners together over the
corner flap.

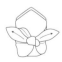

九

Fasten the corners by
making a square knot
(see page 14).

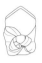

十

Tuck the ends behind
the knot.

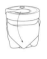

十一

Fold down the fabric flap
and hide the knot.

十二

Adjust the fabric and
knots to make it neat.

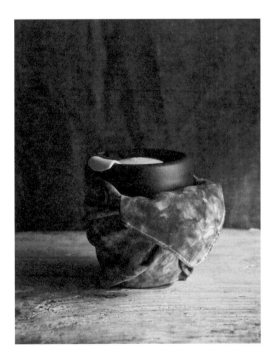

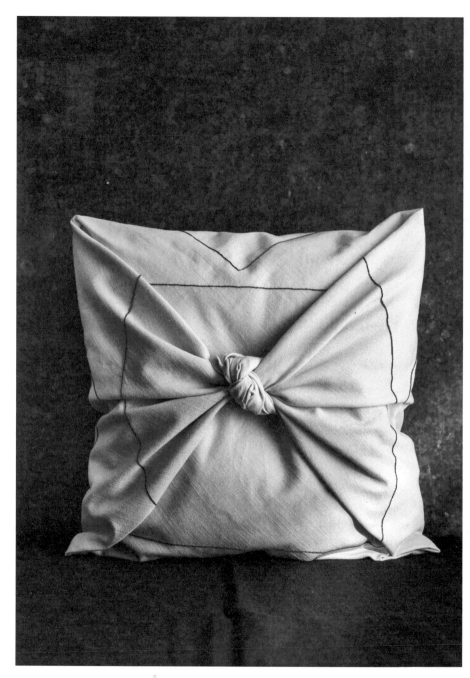

CUSHION
WRAP

クッション包み

You can make a cushion cover using Furoshiki too. It's an easy way to change your home furnishings. It can also be used as a bag, to wrap a gift and for many more occasions. Embroidery is one of the traditional techniques used to add richness to Furoshiki design.

一

Lay your Furoshiki on the diagonal with the design side facing down.

二

Place a 45x45 cm cushion in the centre of your Furoshiki.

三

Fold the bottom corner over the cushion.

四

Fold the top corner over the cushion.

五

Tuck the top corner underneath so you have a straight edge.

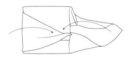

六

Fold the excess fabric on the left side inwards before folding the left corner over the cushion. Repeat with the right corner.

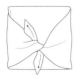

七

Tie the right and left corners and make a square knot (see page 14).

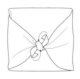

八

Tuck the ends of the corners behind the knot.

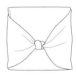

九

Adjust the knot and fabric to make sure it's neat.

+

Turn over to the other
side and check there
are no wrinkles.

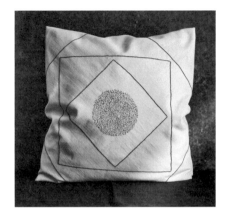

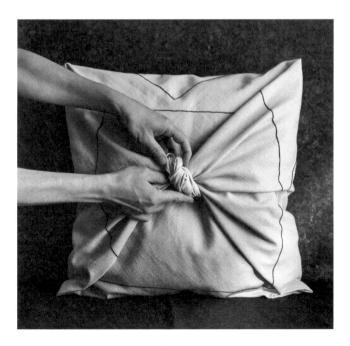

ACKNOWLEDGEMENTS

My gratitude to the staff of Laurence King Publishing for bringing a life to this book, discovering me during a challenging time, giving me hope, joy, and offering enormous encouragement and support. This beautiful book would not exist without Elen Jones who found me and made this opportunity happen, production lead by Simon Walsh, skilful editing by Chelsea Edwards and design by Alex Coco.

I would like to thank the many people who have helped and fostered me in this endeavour: Kuo Kang Chen for his illustrations; Stephanie McLeod, for her photography; Olivia Bennett for styling; Mara Girone, for embroidering the Furoshiki on pages 140 and 143; Yukiko Duncan, for lending us her pottery for pages 42, 60, 84 and 130; Tosatsuru brewer, for providing Sake bottles for pages 42, 84 and 130; my wonderful supportive family and friends.

Last, first and always, my deepest gratitude to my sister Naoko Kakita who loved nature and wanted to plant as many trees as possible in her lifetime. She sadly left this world in 2006. Our Mother Earth, she keeps offering us abundant harvest, beautiful nature we can inhabit and wholesome energy, which inspired me to start my Furoshiki journey.

IMAGE CREDITS

Page 13 images are taken from *Furoshiki: Japanese Wrapping Cloths* (風呂敷), by Akihiko Takemura (竹村昭彦), published by Japan Publications, Inc. (日貿出版社)

Special thanks to the following artisans and independent homewares boutiques for supplying props for the shoot: ALKEMI store (alkemistore.com), Momosan Shop (momosanshop.com), Yukiko Duncan (ydotpottery.co.uk), Yoshihisa Hiromatsu, head of Tosatsuru Sake Brewery (tosatsuru.co.jp) and Sarah Harvey (hebekonditori.com).

STEP-BY-STEP VIDEOS

To watch videos of the author demonstrating each of the wraps, you can scan the QR code below or find them on the Downloads & Extras tab on the Laurence King website:

www.laurenceking.com/product/furoshiki